When you finish reading the title of this book,
you will have read this book.

Lee Garcia

When you finish reading the title of this book, you will have read this book. is an artist's book by Lee Garcia
http://httpdot.net/LeeGarcia

Dedicated to public domain, 2016
ISBN: 978-1-365-41198-4

Published by
HTTPpRESS
http://httpdot.net/HTTPpRESS

*When you finish reading the title of this book, you will have read this book.*

*When you finish reading the title of this book, you will have read this book.*

*When you finish reading the title of this book, you will have read this book.*

*When you finish reading the title of this book, you will have read this book.*

*When you finish reading the title of this book, you will have read this book.*

*When you finish reading the title of this book, you will have read this book.*

*When you finish reading the title of this book, you will have read this book.*

*When you finish reading the title of this book, you will have read this book.*

*When you finish reading the title of this book, you will have read this book.*

*When you finish reading the title of this book, you will have read this book.*

*When you finish reading the title of this book, you will have read this book.*

*When you finish reading the title of this book, you will have read this book.*

*When you finish reading the title of this book, you will have read this book.*

*When you finish reading the title of this book, you will have read this book.*

*When you finish reading the title of this book, you will have read this book.*

*When you finish reading the title of this book, you will have read this book.*

*When you finish reading the title of this book, you will have read this book.*

*When you finish reading the title of this book, you will have read this book.*

*When you finish reading the title of this book, you will have read this book.*

*When you finish reading the title of this book, you will have read this book.*

*When you finish reading the title of this book, you will have read this book.*

*When you finish reading the title of this book, you will have read this book.*

*When you finish reading the title of this book, you will have read this book.*

*When you finish reading the title of this book, you will have read this book.*

*When you finish reading the title of this book, you will have read this book.*

*When you finish reading the title of this book, you will have read this book.*

*When you finish reading the title of this book, you will have read this book.*

*When you finish reading the title of this book, you will have read this book.*

www.ingramcontent.com/pod-product-compliance
Lightning Source LLC
Chambersburg PA
CBHW072310170526
45158CB00003BA/1271